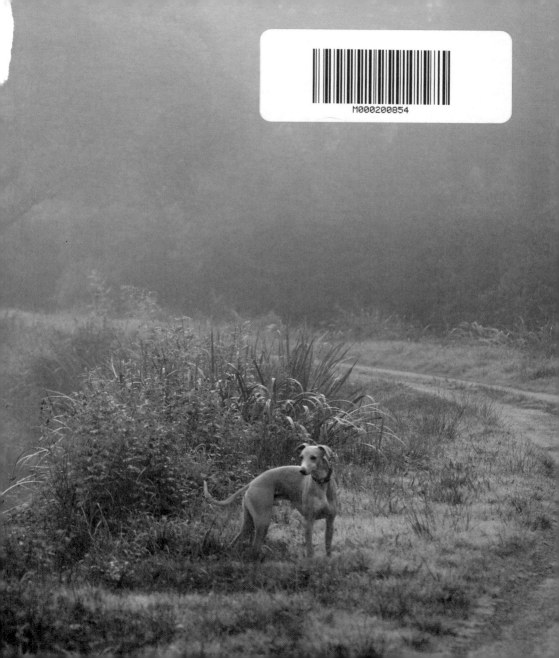

THE FRENCH DOG

Rachael Hale McKenna

Stewart, Tabori & Chang, New York
in association with PQ Blackwell

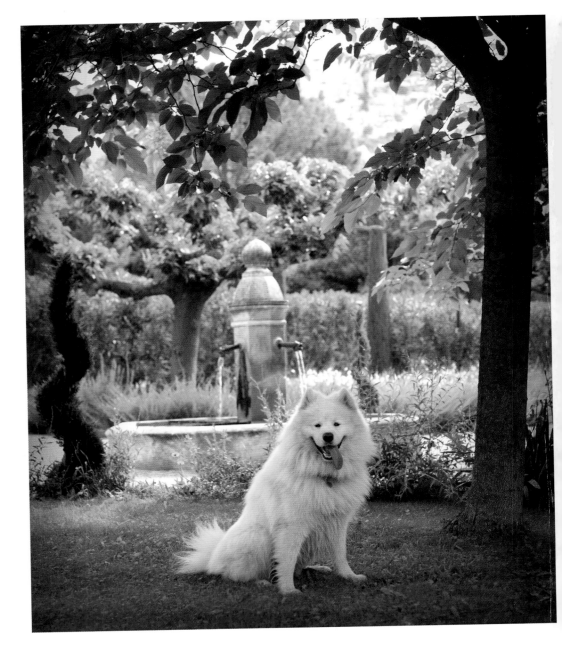

Tous les chiens de France

❧❧❧

Dogs, with their soulful, molten eyes, lithe bodies, and instincts for loyalty, bravery, and hard work, are the photographer's best friend. Dogs delight in being the center of attention. They love to jump, play, and show off.

And French dogs, the best-mannered and well-trained dogs of them all, make superb subjects before the lens.

From the insouciance of the snooty French briard to the sheer joy of the cheeky Jack Russell to the exuberance of the Brittany, French dogs have personality and charm threaded through their very souls.

They also have attitude. They take their place alongside humans; the French dog enters a restaurant, head high, demeanor calm, nonchalantly accepting its welcome into shops, cafés, buses, and trains.

Capturing that moment when a dog lets its emotion show and truly connects with people was my challenge when I began to produce this book. But it was a challenge made much easier by the fact that here in France the dog is as popular as wine—and as sure of its place in society.

France is a wonderful place for dogs, and particularly so for those lucky enough to live in villages. Most have backyards, and many are also allowed to wander freely through the paddocks and vineyards that surround the village. Market dogs spend their lives in the back of vans or snuggled into empty fruit trays. Markets are a daily event throughout France—locals shop there as part of life, often with their dogs at their heels, and everyone goes home with arms full of superb antiques, sweets, local pottery, table linens, or flowers. But luckiest of all are the *chiens de châteaux*, guardians of France's fabulous country houses.

French dogs are social creatures. They love other dogs. Best of all, they love people. All of which means there's a lot of boisterous fun in this book. But for me, at heart this is a series of images that gets inside the very soul of a dog.

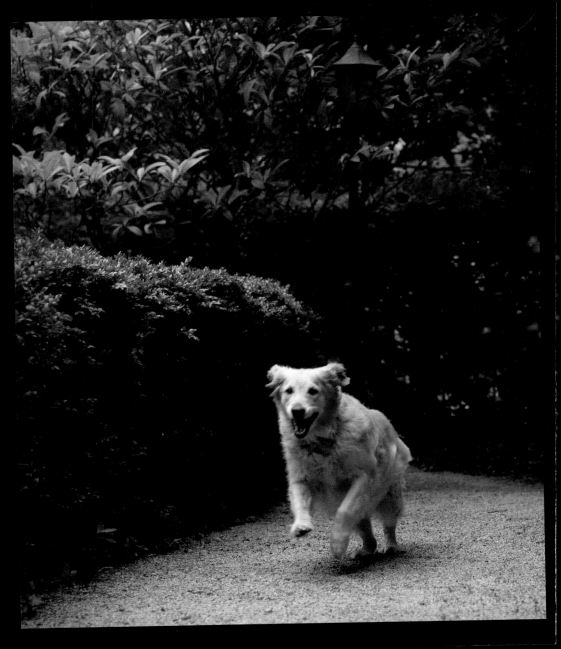

Qui aime Bertrand,
aime son chien.

Love me, love my dog.

(Literally "He who loves Bertrand,
loves his dog.")

———————

French proverb

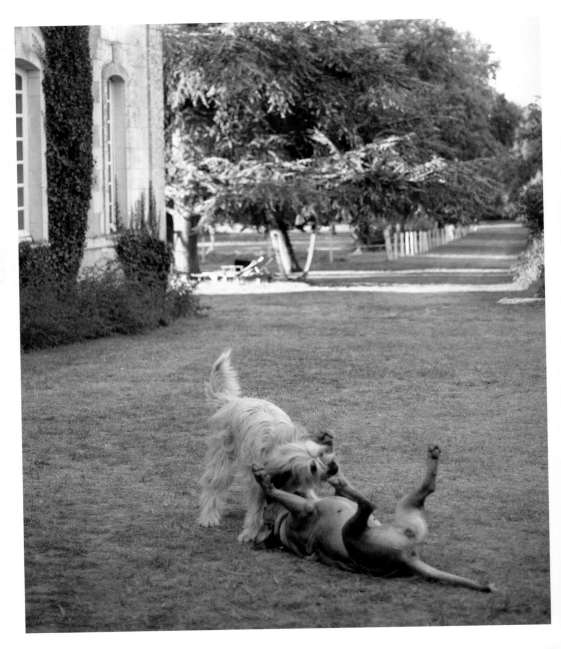

Bon chien chasse de race.

A well-bred dog hunts by nature.

French proverb

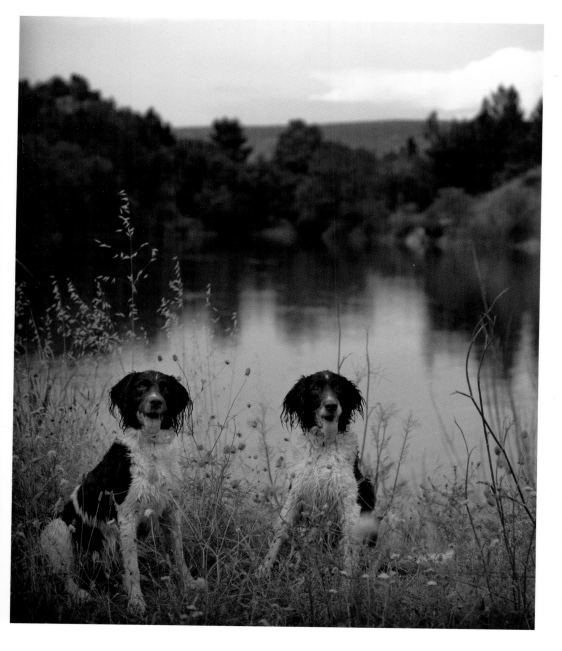

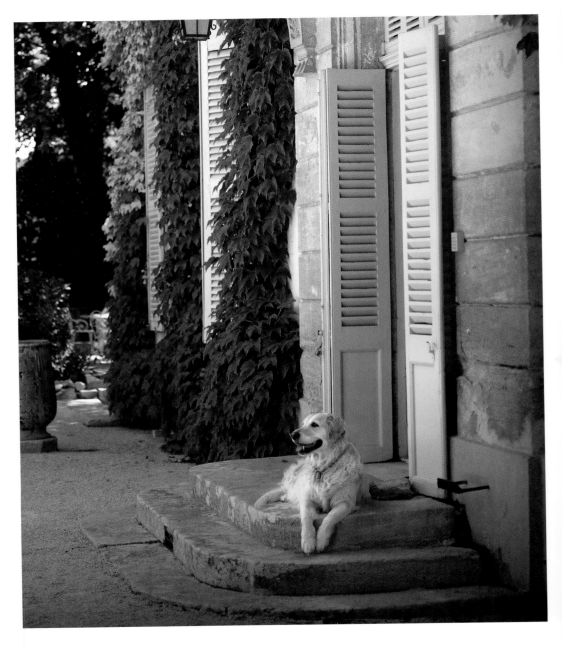

Tchipie

Tchipie is the ideal resident for Château de Varenne, which is run as an exquisite hotel. She poses beautifully on the top step of the entrance—the perfect spot to welcome new guests. Then, when she's in a playful mood, Tchipie entertains them by running through the manicured gardens, playing endlessly with her well-worn ball.

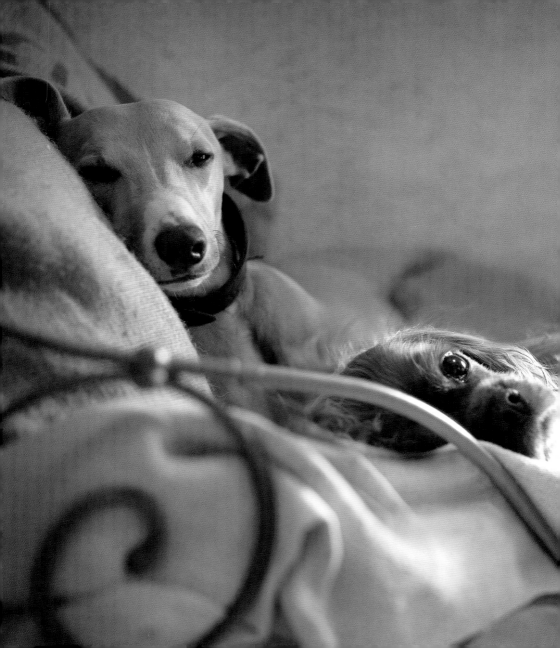

A lover tries to
stand in well with the pet
dog of the house.

—————————————————

Molière
(1622–73, French playwright, actor, and director)

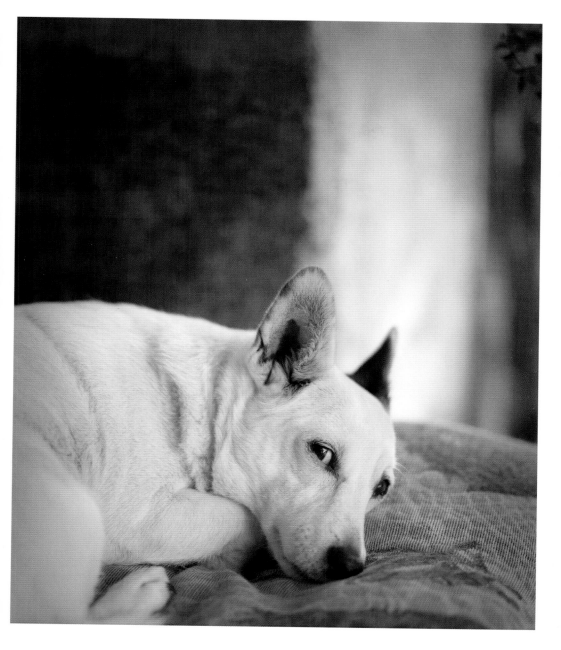

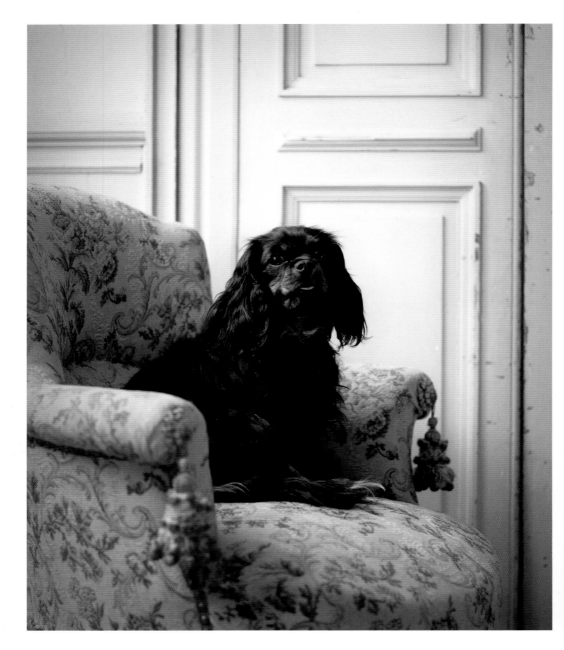

Joséphine de Beauharnais (1763–1814, empress of France)

Joséphine de Beauharnais and her beloved pug, Fortune, were inseparable. A popular legend exists that Fortune used to smuggle messages secreted in his collar to Joséphine's family when she was imprisoned during the French Revolution.

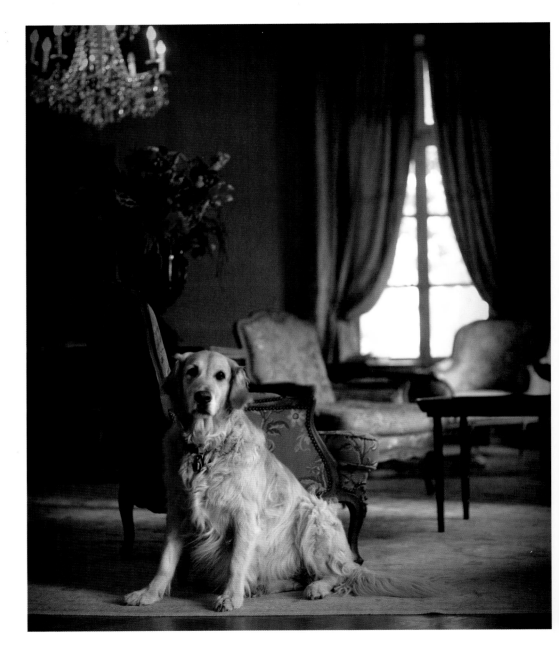

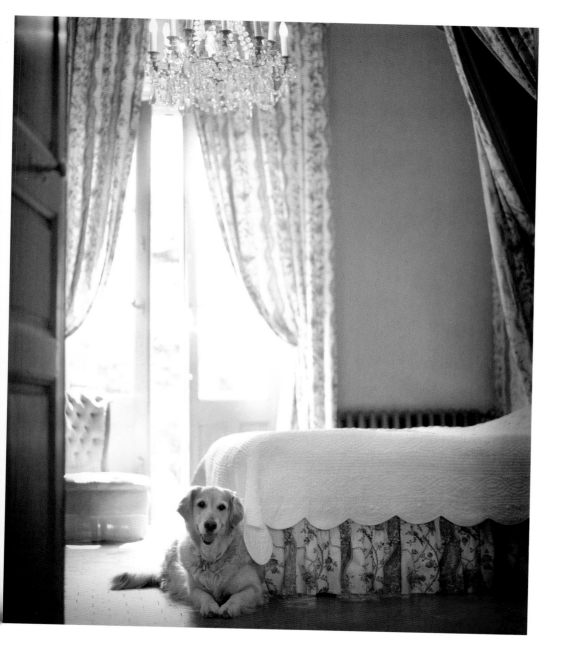

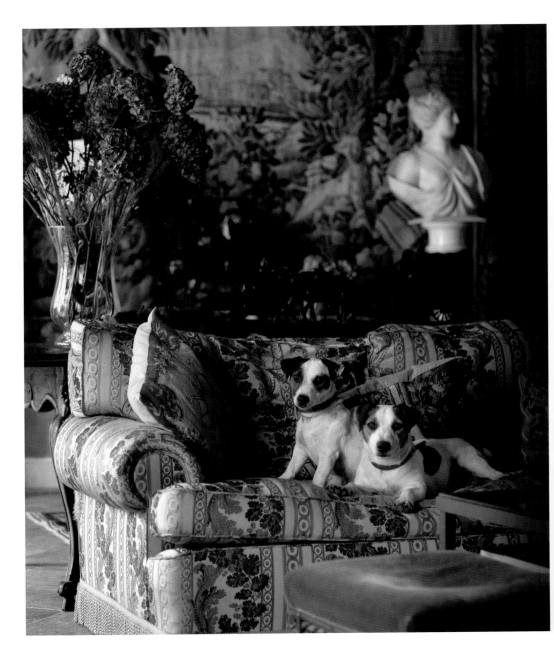

Duke & Elvis

The two cheeky and highly energetic Jack Russell brothers of the beautiful Château de Beauregard, Duke and Elvis, head out to the horse paddock every morning for a game with the gray stallion, running circuits around the field. Their rewards when they come to a stop after their morning outburst: a sit on the horse for Elvis and later a nap back at the château for both.

Would that I were, too, a lap-dog!

Paul Verlaine
(1844–96, French poet)
From "Sur l'herbe," 1907

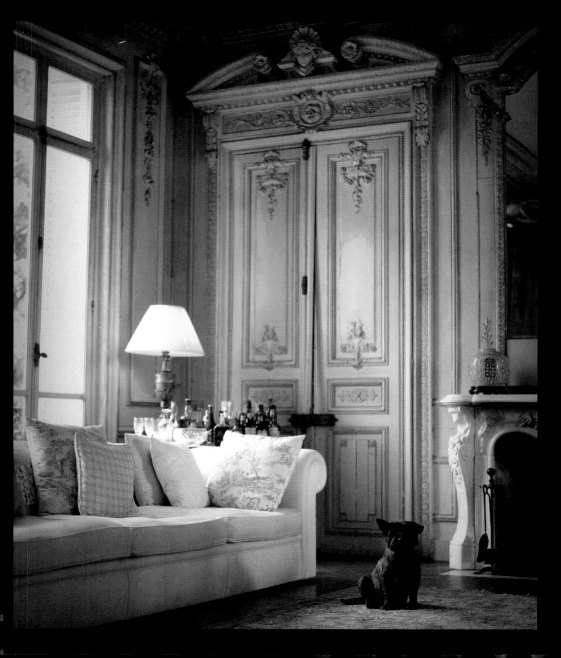

Coco Chanel (1883–1971, French fashion designer)

While in her early twenties, Gabrielle Chanel, who later became the iconic fashion designer Coco Chanel, had a brief stint as a cabaret singer at La Rotonde, a Montparnasse café. She acquired her nickname from a song she used to perform about a woman who loses her dog at the Trocadéro amusement park. The audience would shout out "Coco! Coco!" imploring Chanel to sing the song.

I've lost my poor Coco.
Coco, my lovable dog.
Lost him, close to the Trocadéro.
He's far away, if he's still running.
I admit my biggest regret is that the more my man cheated me,
the more Coco remained faithful.

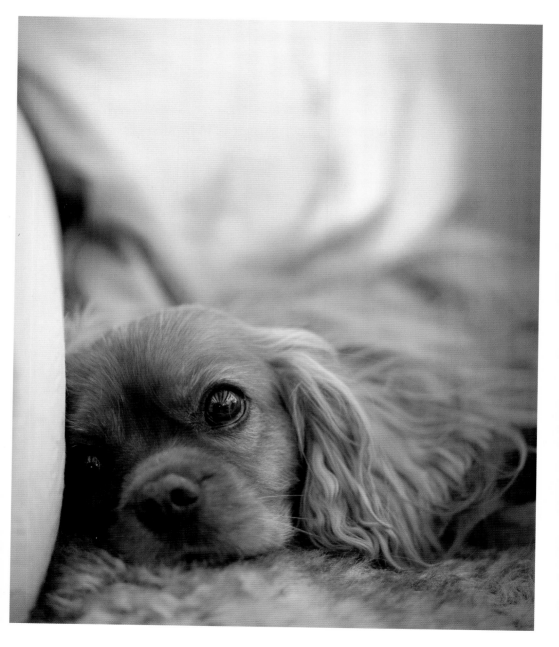

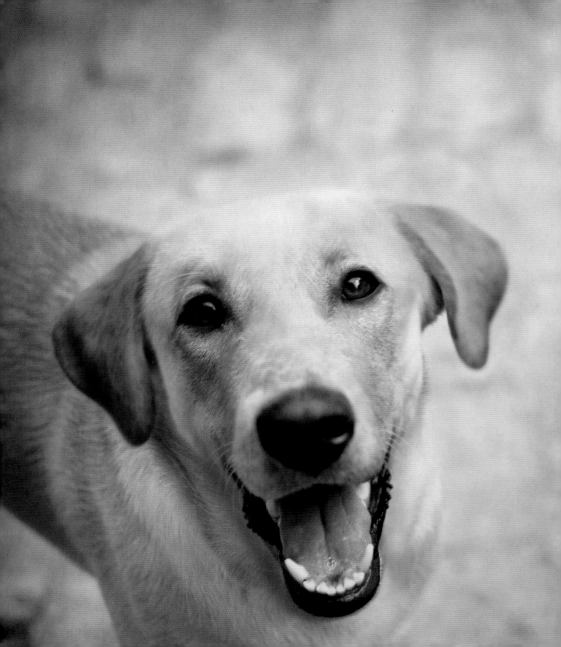

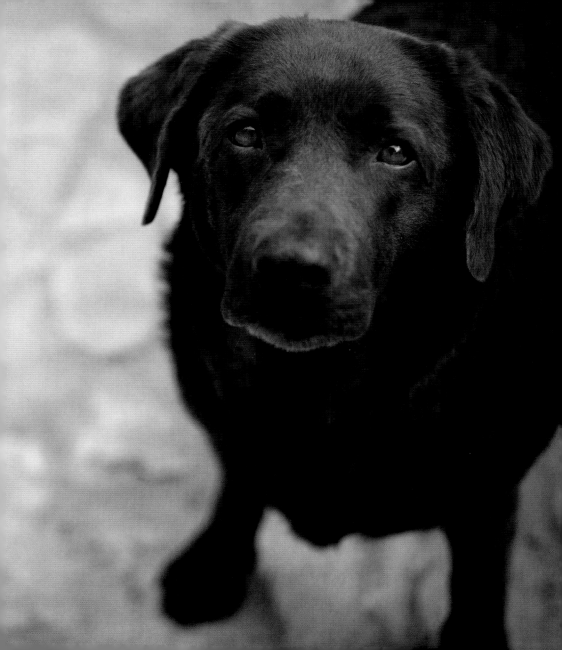

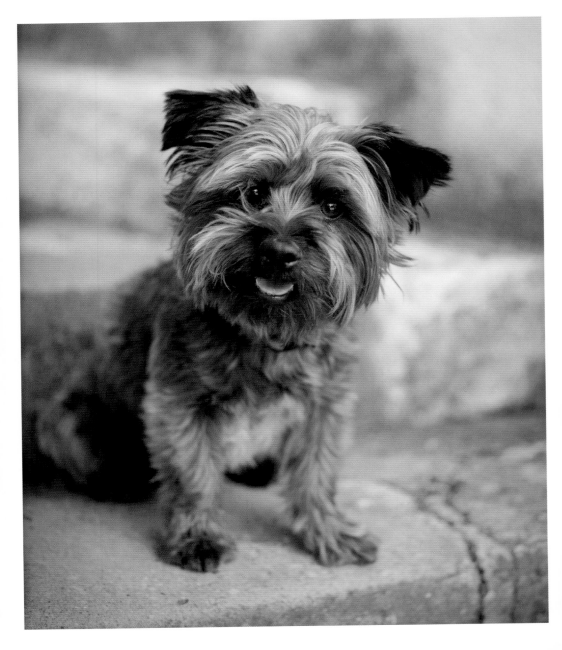

The best thing about a man is his dog.

French proverb

Yves Saint Laurent (1936–2008, French fashion designer)

Legendary fashion designer Yves Saint Laurent owned a succession of French bulldogs throughout his life, all with the same name: Moujik. They would accompany the designer everywhere he went, even to nightclubs. One even had his portrait painted by Andy Warhol in 1986, the last portrait ever done by the artist.

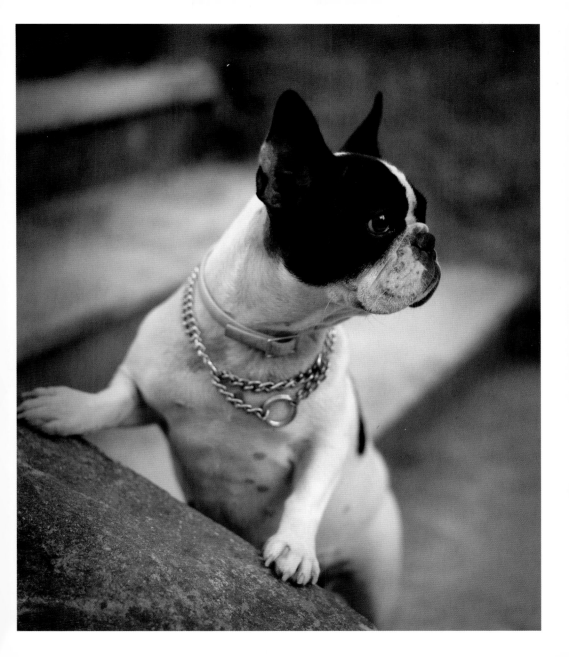

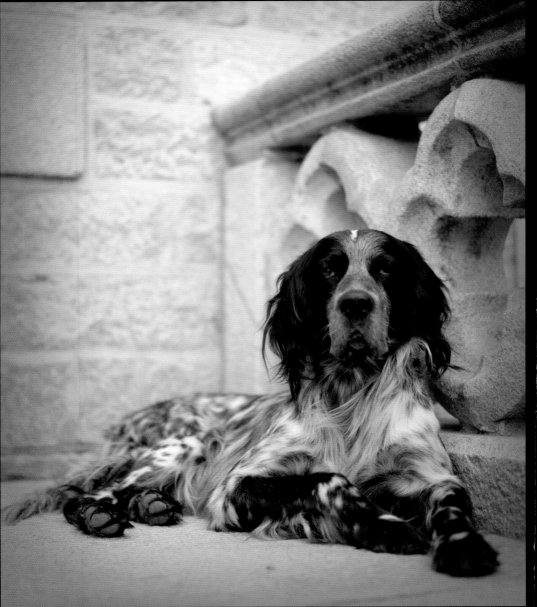

Plus je vois les hommes,
plus j'admire les chiens.

The more I see of men,
the better I like dogs.

Blaise Pascal
(1623–62, French mathematician, writer, and philosopher)

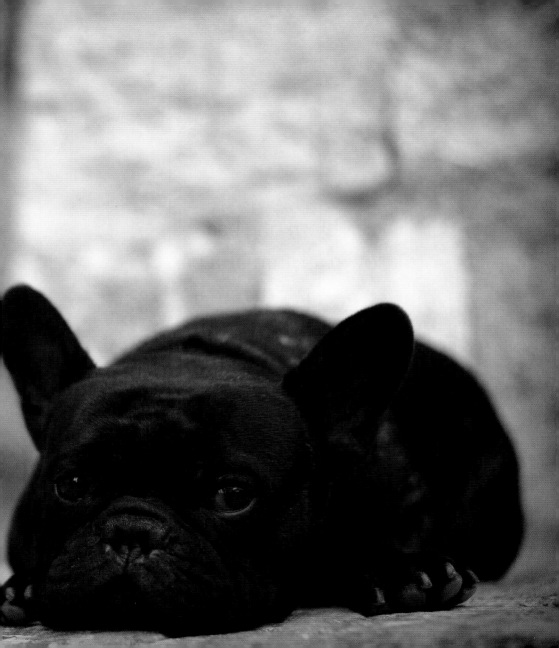

Until one has
loved an animal, a part
of one's soul remains
unawakened.

Anatole France
(1844–1924, French poet, novelist, and journalist)

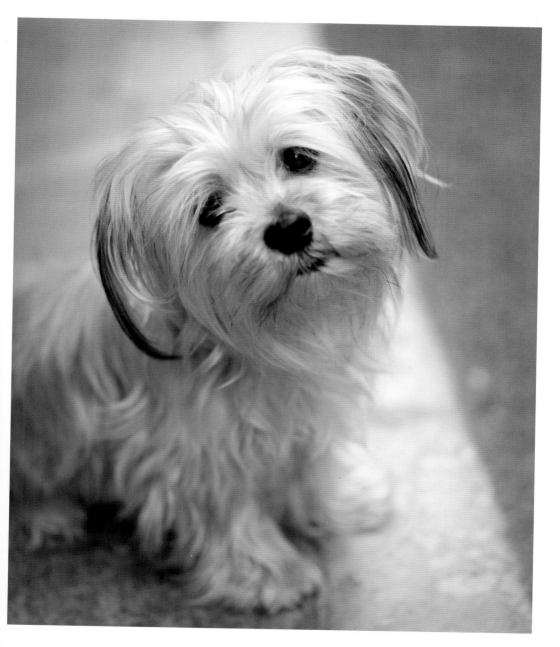

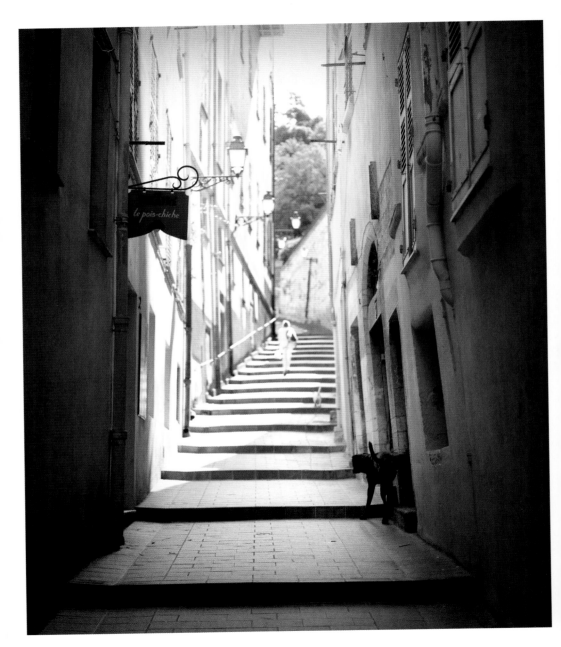

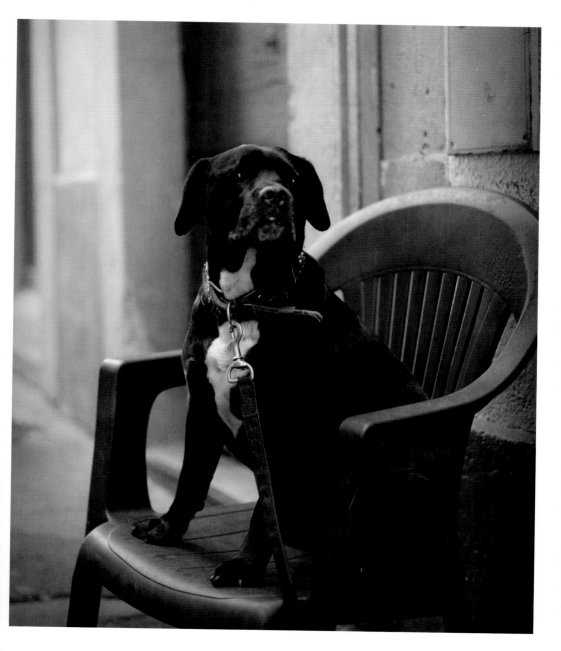

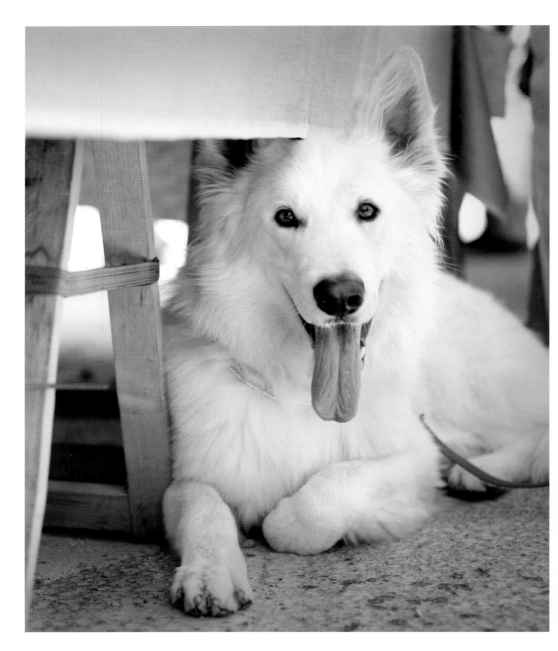

A dog hath true love,

A dog hath right good understanding,

A wise dog knoweth all things,

A dog hath force and kindliness,

A dog hath mettle and is comely,

A dog is in all things seemly.

A knowing dog thinketh no evil,

A dog hath a memory that forgeteth not,

I say unto you again a dog forsaketh not his duty,

Have might and cunning therewith

and a great brave heart.

Gace de la Vigne
From "Poème sur la chasse," 1359

Marie Antoinette (1755–93, queen of France)

It is said that Marie Antoinette, a true dog devotee, walked up to the guillotine carrying her papillon under her arm. The dog, whose life was spared, was later cared for in a building in Paris named after it.

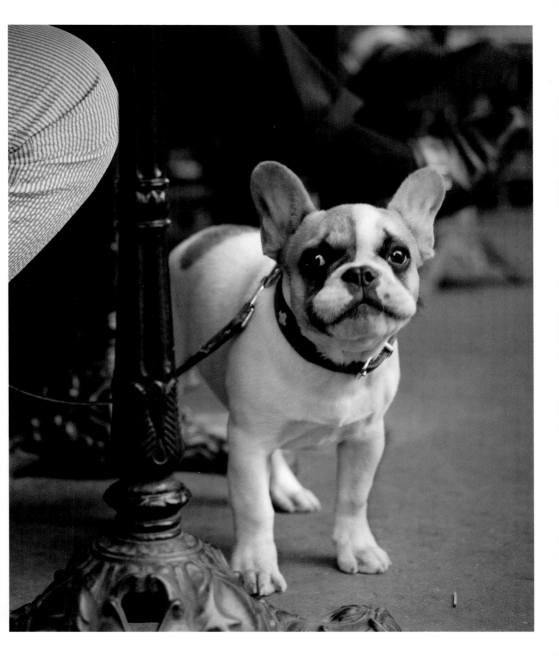

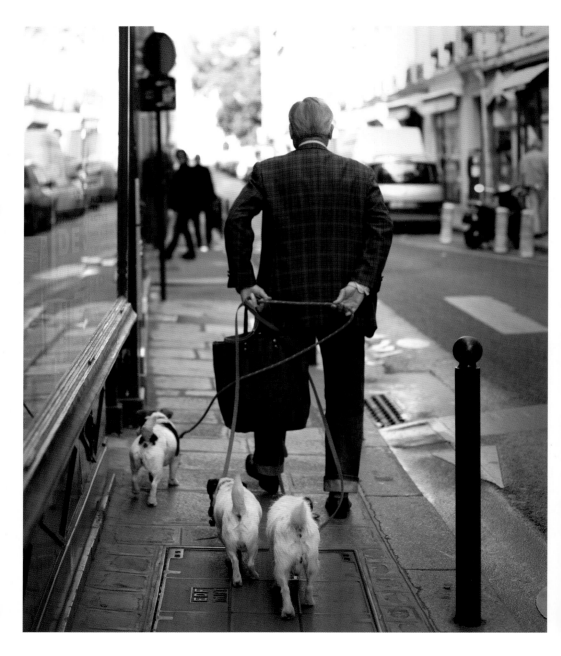

Dogs are part of the fiber of daily life in Paris.

Barbara Wilde

(American expatriate living in Paris)

Louis XV (1710–74, king of France)

Dogs were an important feature at the Palace of Versailles. Emulating his great-grandfather's passion for his hounds, Louis XV created a room especially devoted to his dogs, decorated with motifs of the hunt, where the dogs slept in small kennels with padded mattresses adorned with braid.

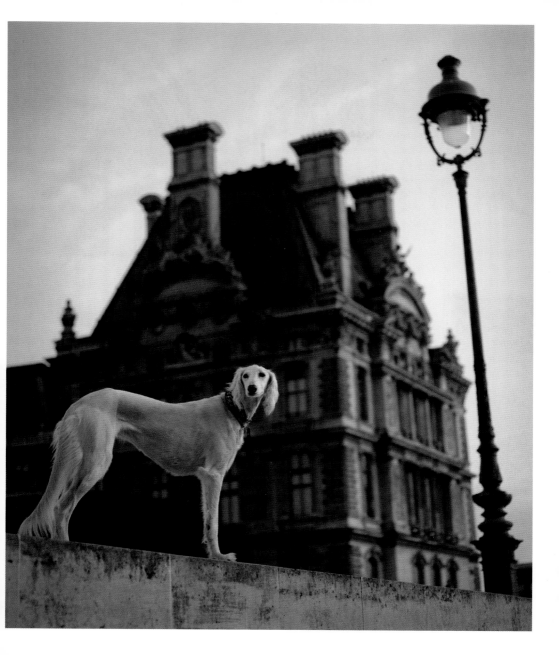

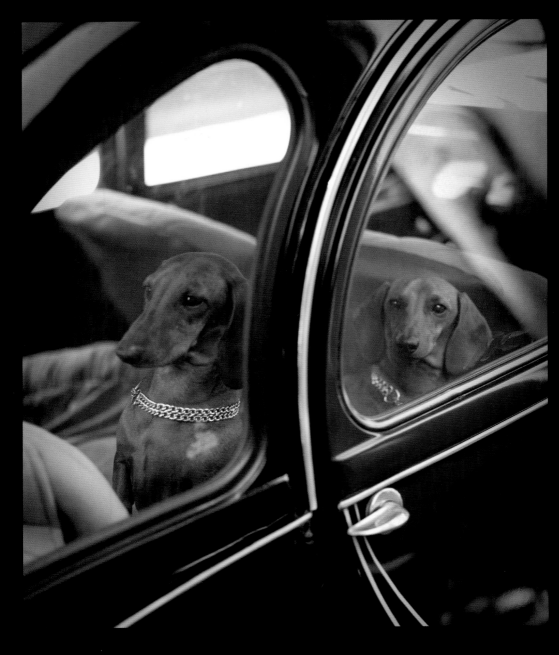

"Where are the dogs going?"
you people who pay so little attention ask.
They are going about their business. And
they are very punctilious, without wallets,
notes, and without briefcases.

Charles Baudelaire
(1821–67, French poet and critic)

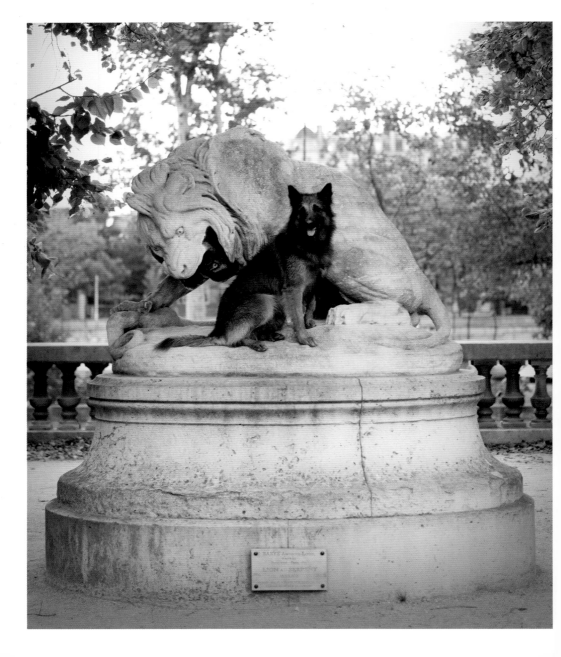

Flash

I first noticed Flash when photographing dogs at the Jardin des Tuileries, near the Louvre in Paris, one of the few places dogs can run free in the heart of the city. Instantly, at a soft command from Koffi, his owner, the ten-month-old Belgian shepherd leaped up onto a statue for this pose.

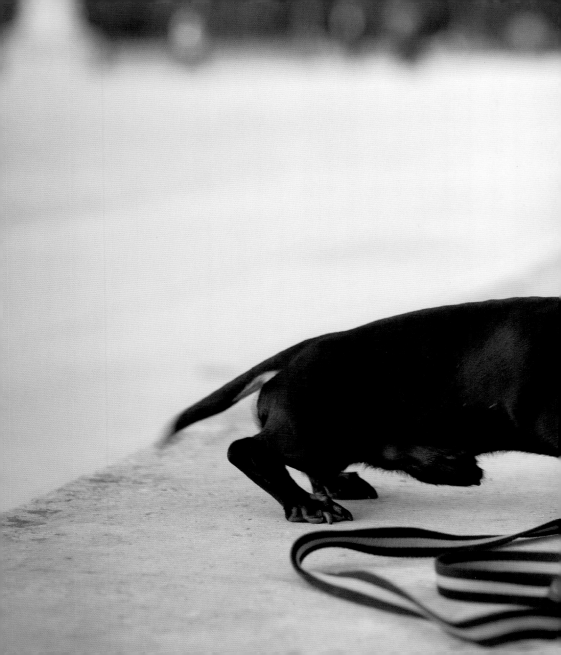

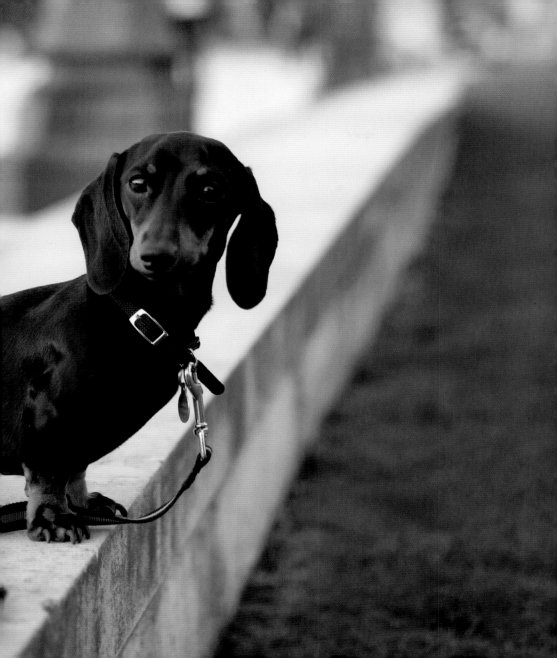

Dog! … What can be
the meaning of the obscure
love for me that has sprung
up in your heart?

———————————

Anatole France
(1844–1924, French poet, novelist, and journalist)

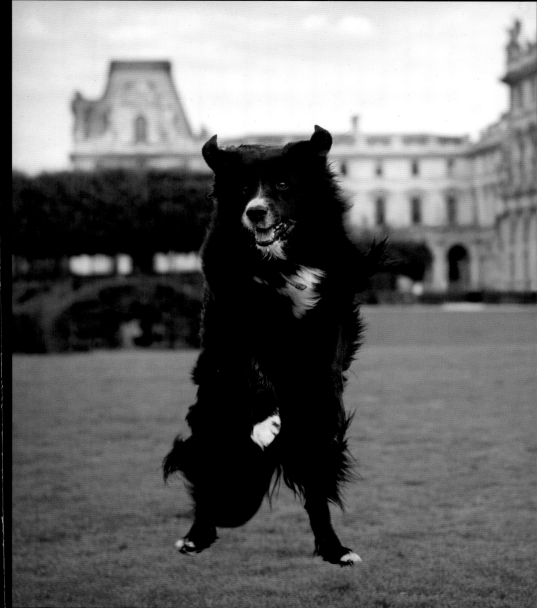

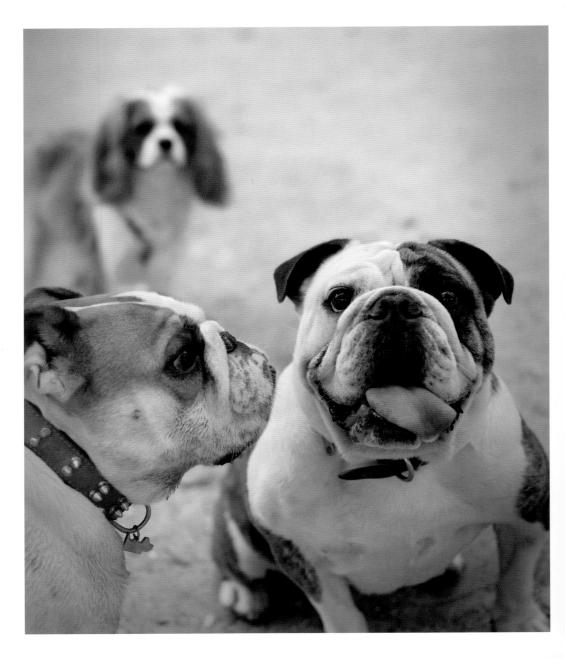

The dog has no ambition,
no self-interest, no desire for
vengeance, no fear other than
that of displeasing.

Georges-Louis Leclerc, comte de Buffon
(1707–88, French naturalist)

Sidonie-Gabrielle Colette (1873–1954, French writer and performer)

Animals were a major theme in the works of the French writer known as Colette, and *Dialogues de bêtes*, published as *Barks and Purrs* in 1913, features a series of imaginary conversations between her French bulldog, Toby-Dog, and a Maltese cat, Kiki-the-Demure. Perhaps Colette was thinking of Toby-Dog when she wrote the following words:

Bulldogs are adorable, with faces like toads that have been sat on.

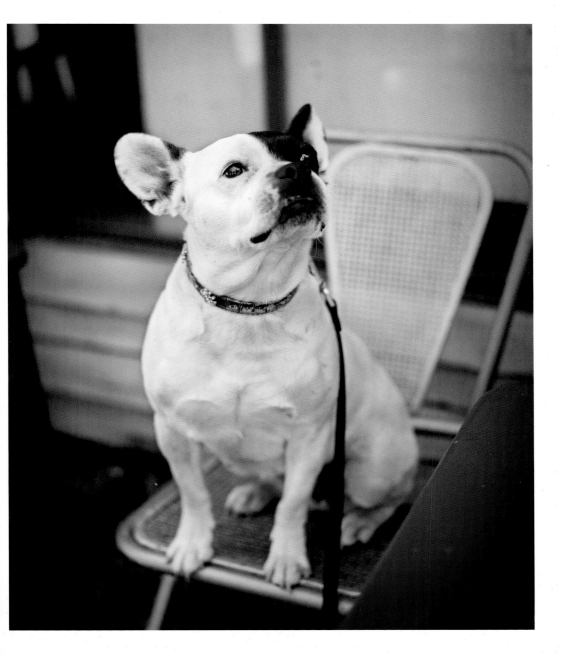

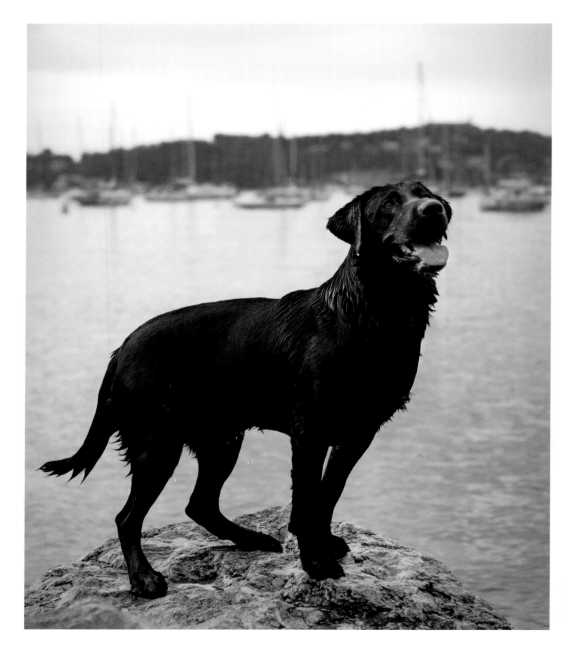

Napoléon Bonaparte (1769–1821, French military and political leader)

Here, Gentlemen, a dog teaches us a lesson in humanity.

Legend has it that Napoléon said these words after he slipped on his ship and fell overboard. Napoléon did not know how to swim and was saved from the depths by a brave dog that kept him afloat until he could be rescued.

The rich man's guardian,
and the poor man's friend, the only
creature faithful to the end.

———————————————

George Crabbe
(1754–1832, English poet and naturalist)

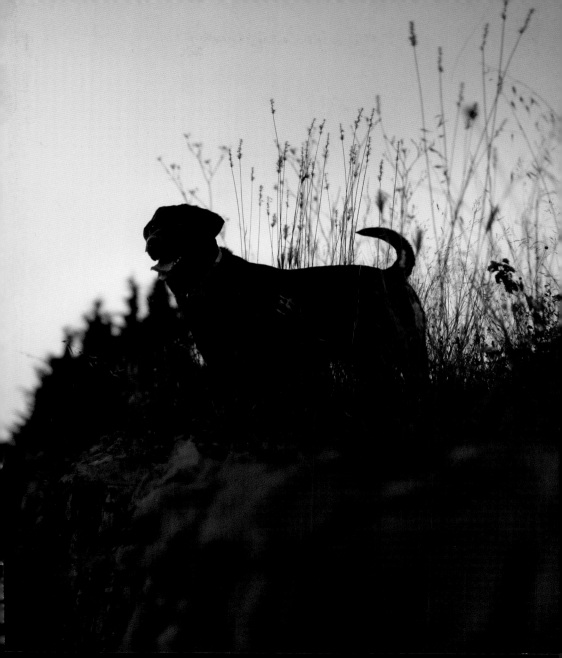

Images (by page)

Front cover: Lola (Lhasa apso), Grasse, Provence
Case: Corianda (cavalier King Charles spaniel), Manoir de Kerlédan, Carhaix-Plouguer, Bretagne
Front endpaper: Dazzie (whippet), Manoir de Kerlédan, Carhaix-Plouguer, Bretagne
p. 2: D'Shasta (Samoyed), La Cabro d'Or, Les Baux de Provence, Provence
p. 4: Tchipie (golden retriever), Château de Varenne, Sauveterre, Provence
pp. 6, 7: Aslan (bearded collie mix) and Emoi (bullmastiff), Château de l'Epinay, Saint-Georges-sur-Loire, Pays de la Loire
p. 9: Chelsey and Yentl (small Münsterländers), Orgon, Provence-Alpes-Côte d'Azur
p. 10: Tchipie (golden retriever), Château de Varenne, Sauveterre, Provence
pp. 12–13: Dazzie (whippet) and Corianda (cavalier King Charles spaniel), Manoir de Kerlédan, Carhaix-Plouguer, Bretagne
p. 15: Portia (Jack Russell mix), Peyrat, Abjat-sur-Bandiat, Aquitaine
p. 16: Elina (cavalier King Charles spaniel), Lieuran-lès-Béziers, Languedoc-Roussillon
pp. 18, 19: Tchipie (golden retriever), Château de Varenne, Sauveterre, Provence
p. 20: Duke and Elvis (Jack Russell brothers), Château de Beauregard, Jonquières, Provence
p. 23: Peppie (cairn terrier), Château Bosgouet, Bosgouet, Haute-Normandie
p. 25: Corianda (cavalier King Charles spaniel), Manoir de Kerlédan, Carhaix-Plouguer, Bretagne
pp. 26–27: Toscana (Labrador mix) and Kaya (chocolate Labrador), Les Baux de Provence, Provence
p. 28: Poky (terrier mix), Ventabren, Provence;
p. 31: Effy (French bulldog), Autignac, Languedoc-Roussillon
p. 32: Pollux (English setter), Château du Val, Planguenoual, Bretagne
pp. 34–35: Diesel (French bulldog), Les Baux de Provence, Provence
p. 37: Lola (Lhasa apso), Grasse, Provence;
pp. 38, 39: Vieux Nice, Côte d'Azur
p. 40: white shepherd, Coustellet, Provence;
p. 43: Griffon (French bulldog puppy), Saint-Germain-des-Prés, Paris
p. 44: Saint-Germain-des-Prés, Paris
p. 47: Heyla (saluki), in front of the Louvre, Paris
p. 48: Napoléon and Mistral (dachshunds), Maussane-les-Alpilles, Provence
p. 50: Flash (Belgian shepherd), Place de la Concorde, Paris
pp. 52–53: Julot (miniature dachshund), Paris;
p. 55: Simba (border collie mix), Jardin des Tuileries, Paris
p. 56: Bailey (English bulldog), Princess (English bulldog), and Cava (cavalier King Charles spaniel), Champ de Mars, Paris
p. 59: Victoria (French bulldog–Jack Russell mix), L'Isle-sur-la-Sorgue, Provence
p. 60: Laku (Labrador retriever), Villefranche-sur-Mer, Côte d'Azur
pp. 62–63: Cookie (Labrador retriever), Causses-et-Veyran, Languedoc-Roussillon
Back endpaper: Flash (Belgian shepherd), Place de la Concorde, Paris
Back cover: Dazzie (whippet), Carhaix-Plouguer, Bretagne

For Abrams:
Editor: Laura Dozier
Production manager: Jake Wilburn

For PQ Blackwell:
Publisher: Geoff Blackwell
Editor in chief: Ruth Hobday
Editorial: Lisette du Plessis and Rachel Clare
Book design: Helene Dehmer

Library of Congress Control Number: 2015949314
ISBN 978-1-61769-187-4

Images copyright © 2016 Rachael Hale Trust
www.rachaelmckenna.com

First edition published in 2016 by Abrams
Concept and design copyright © 2016 PQ Blackwell Limited
Text copyright © 2016 Rachael Hale McKenna and Carroll du Chateau
Published in 2016 by Stewart, Tabori & Chang, an imprint of ABRAMS.

Printed by 1010 Printing International Limited
Responsibly printed and bound in China
10 9 8 7 6 5 4 3 2 1

Stewart, Tabori & Chang books are available at special discounts when
purchased in quantity for premiums and promotions as well as fundraising or
educational use. Special editions can also be created to specification. For details,
contact specialsales@abramsbooks.com or the address below.

115 West 18th Street
New York, NY 10011
www.abramsbooks.com

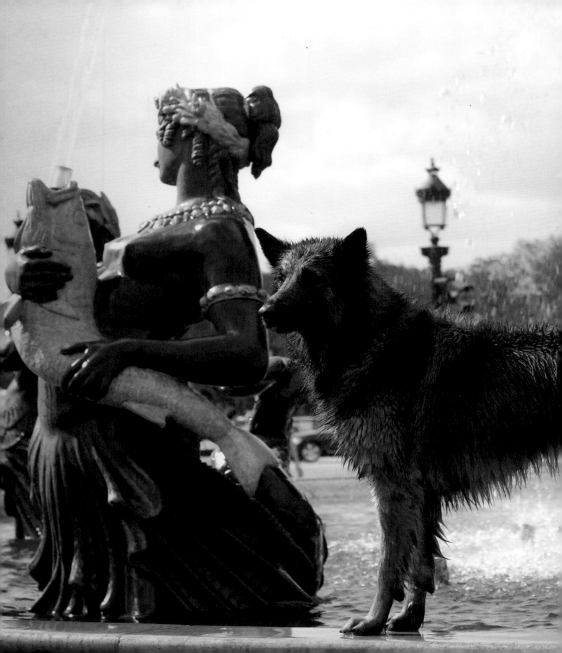